Acknowledgments

This project has had an unusual trajectory, one both highly localized in DePaul University and also connected to international academic centers and unpredictable academic disciplines. It began in 2003, when Ryan Feigenbaum, a DePaul student majoring in philosophy, noticed that the campus security guard in his dormitory passed the late shift by drawing. Their conversations led Ryan to introduce members of the philosophy department to the artist, Peter Karklins, rightly suspecting that they would respond to his interest in phenomenology, Jungian theory, and Greek philosophy. Internal discussions of the drawings and their implications quickly expanded to include colleagues at other universities, generating so much interest and commentary that in rapid sequence a publication, symposium, and exhibition took shape.

Sean Kirkland, Associate Professor in the Philosophy department, has spearheaded the project with energy and enthusiasm, successfully enlisting a diverse group of scholars with an even wider range of disciplinary interests. He has also helped to select the works shown in the exhibition and served as general editor of the publication. We thank the contributors, who have shown such willingness to participate and whose perspectives deeply enrich our understanding of this material. Charles Suchar, Dean of the Liberal Arts and Social Sciences, has provided welcome support for the project, as have the departments of Philosophy, History of Art and Architecture, and Environmental Studies, as well as the Institute of Nature and Culture and the Humanities Center. Finally, we are grateful to Peter Karklins for his generosity in sharing his intensely personal and compelling work with a wide audience.

Louise Lincoln
Director, DePaul Art Museum

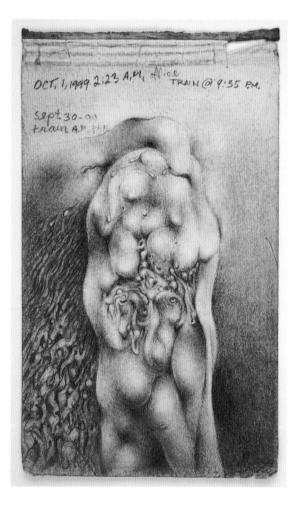

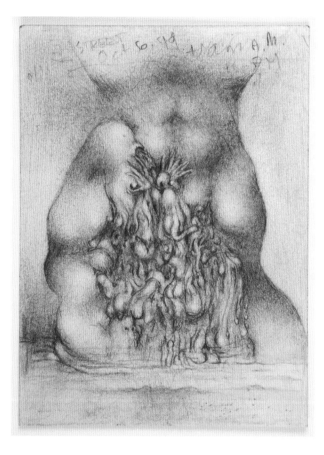

1 | *10.6.99*
5 x 3 in.

2 | *10.11.99*
4 x 3 in.

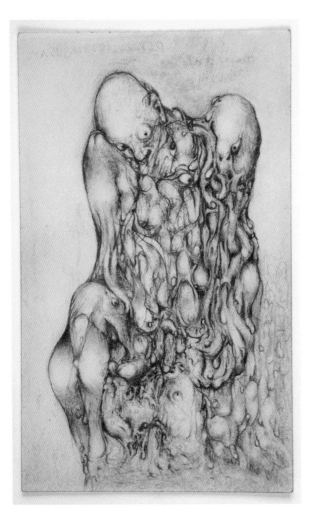

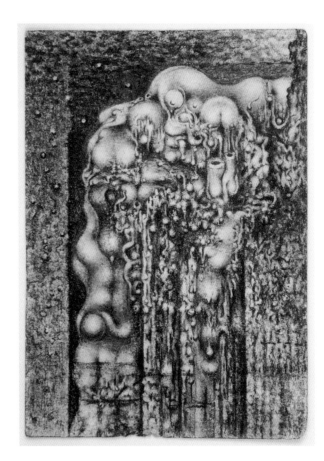

3 | *10.22.99*
4 7/8 x 3 in

4 | *1.11.00*
4 3/16 x 3 in

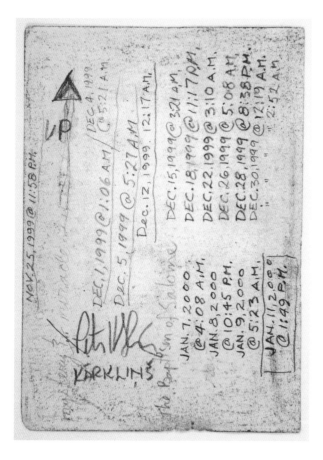

Nov. 25, 1999 @ 11:58 P.M.

UP

DEC. 4, 1999.
@ 5:21 A.M.

DEC. 1, 1999 @ 1:06 A.M.

DEC. 5, 1999 @ 5:27 A.M.

Dec. 12, 1999. 12:17 A.M.

DEC. 15, 1999 @ 3:21 A.M.
DEC. 18, 1999 @ 11:17 P.M.
DEC. 22, 1999 @ 3:10 A.M.
DEC. 26, 1999 @ 5:08 A.M.
DEC. 28, 1999 @ 8:38 P.M.
DEC. 30, 1999 @ 12:19 A.M.
2:51 A.M.

JAN. 7. 2000
@ 4:08 A.M.
JAN. 8, 2000
@ 10:45 P.M.
JAN. 9, 2000
@ 5:23 A.M.

JAN. 11, 2000
@ 1:49 P.M.

KARKLINS

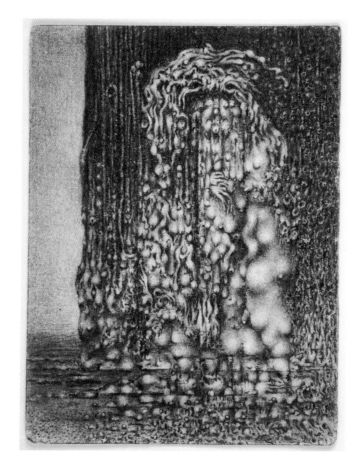

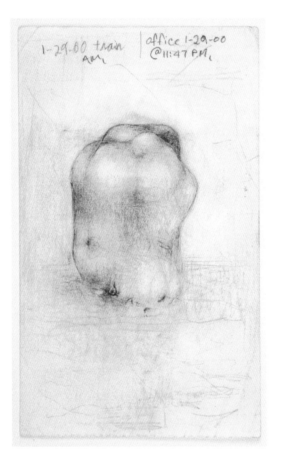

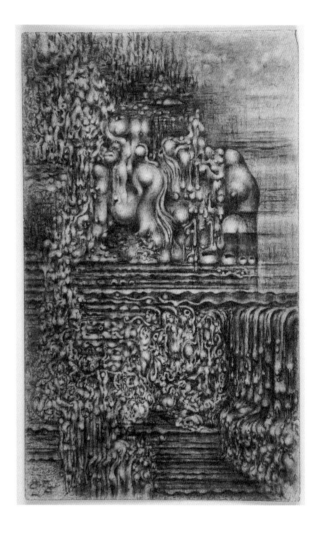

6 | *1.29.00*
4 3/16 x 3 1/4 in

7 | *2.14.00*
4 15/16 x 3 in

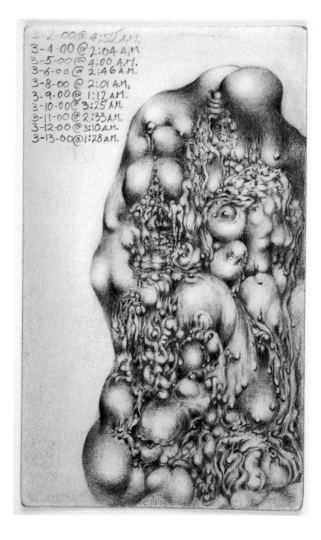

7 (Verso) | *2.14.00*

8 | *3.13.00*
5 x 3 in

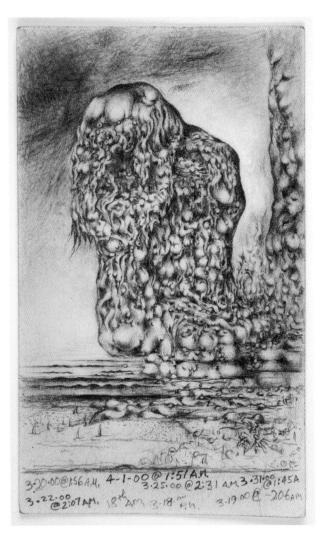

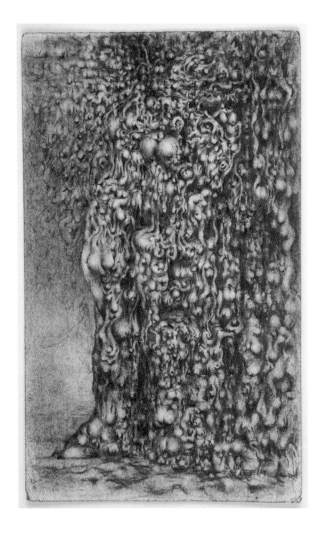

9 | *4.1.00*
5 x 3 in

10 | *5.28.00*
4 15/16 x 3 in

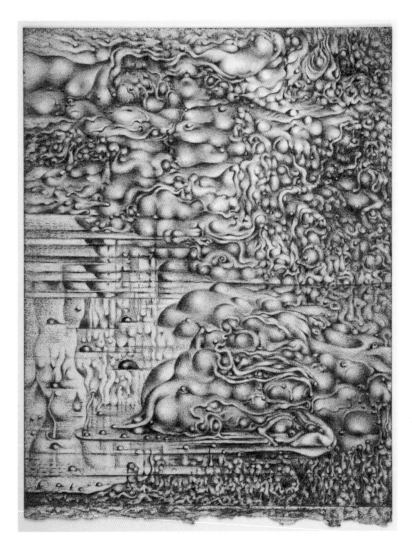

11 | *4.16.01*
5 1/2 x 4 1/4 in

11 (Verso) | *4.16.01*

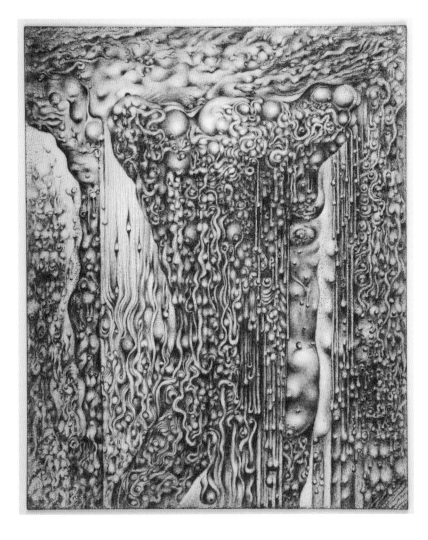

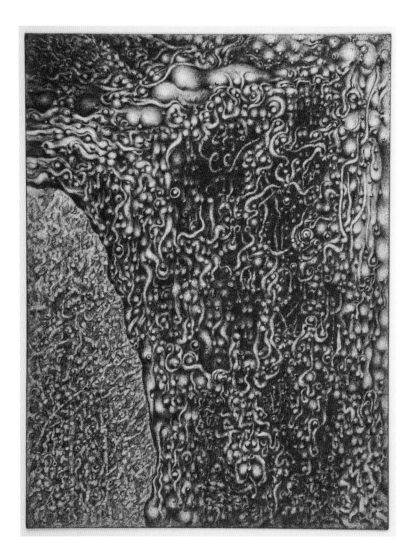

12 | *10.12.01*
 6 x 4 7/8 in
 Private collection

13 | *4.24.02*
 5 5/8 x 4 15/16 in

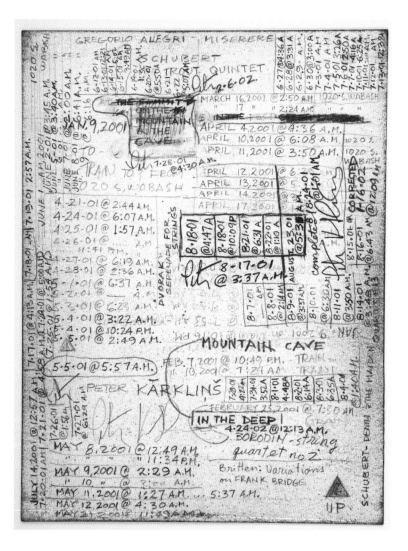

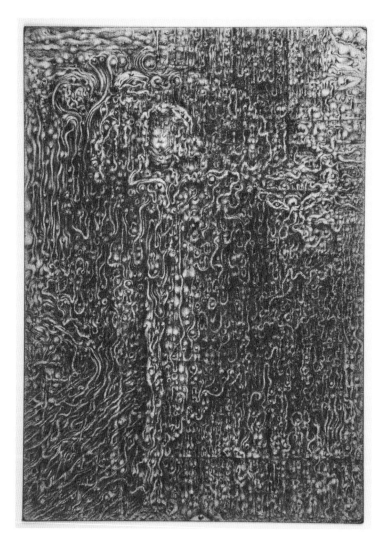

13 (Verso) | 4.24.02

14 | 8.27.02
6 7/8 x 4 15/16 in

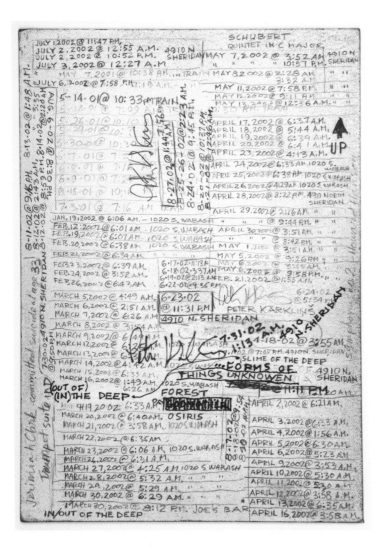

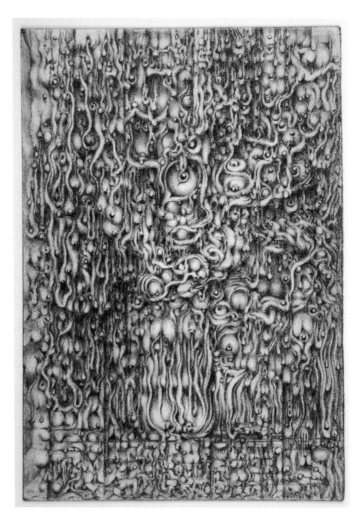

14 (Verso) | 8.27.02

15 | 1.26.03
4 7/8 x 3 7/16 in

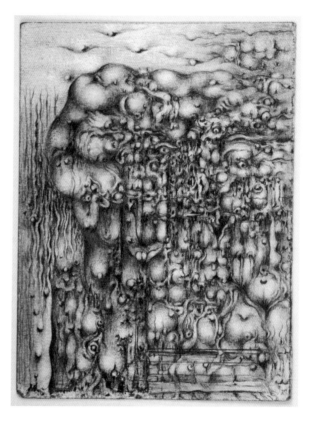

15 (Verso) | 1.26.03

16 | 2.18.03
4 x 3 in

16 (Verso) | *2.18.03*

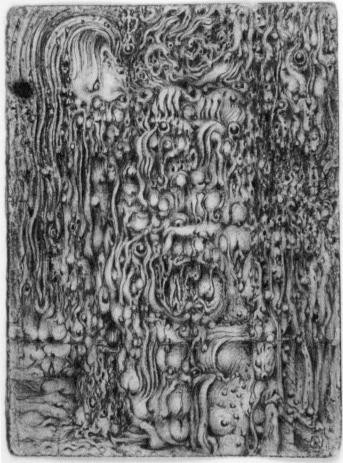

17 | *2.22.03*
4 7/8 x 3 in
Private collection

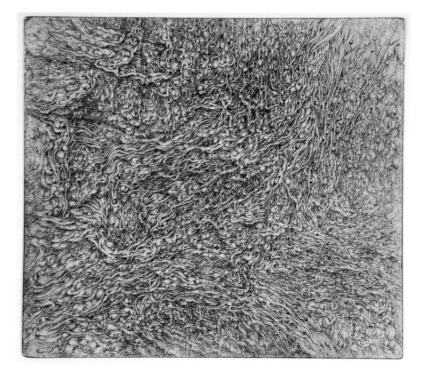

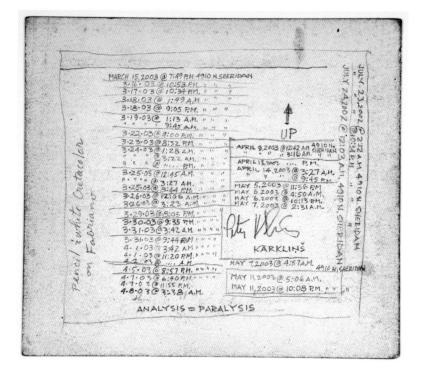

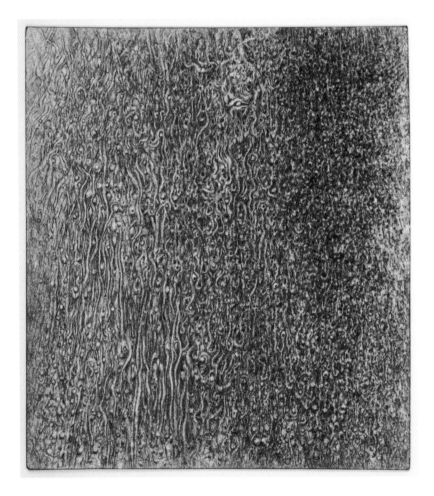

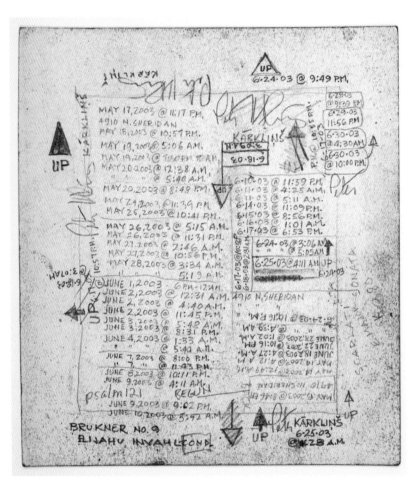

19 | *6.30.03*
 6 15/16 x 6 5/16 in

19 (Verso) | *6.30.03*

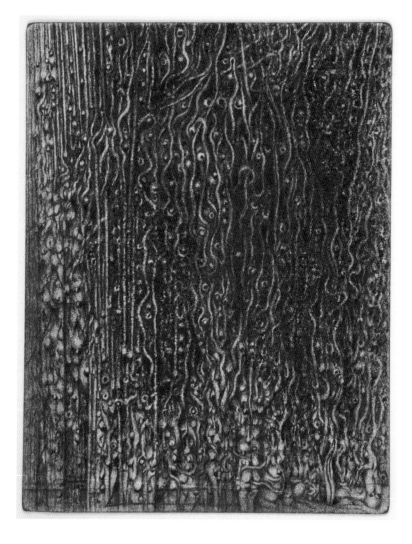

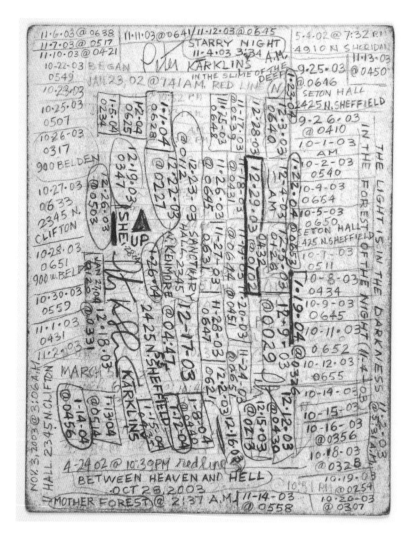

20 | 1.23.04
4 7/8 x 3 3/4 in

20 (Verso) | 1.23.04

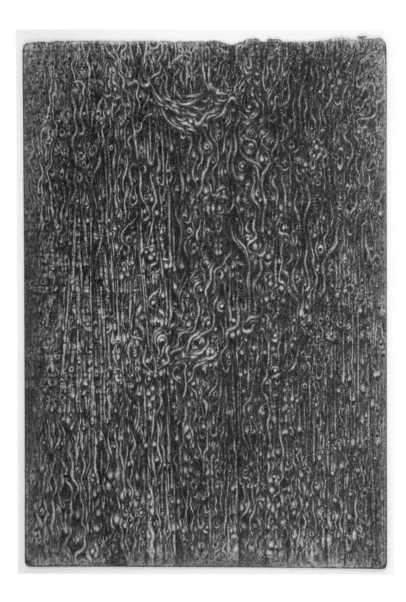

21 | 5.26.04
6 7/8 x 4 7/8 in

art⇒nature

Nude Landscapes
Sean D. Kirkland

The individual, with all limits and measures, was submerged here in the self-oblivion of the Dionysian condition and forgot the statutes of Apollo. Excess unveiled itself here as truth; contradiction, bliss born of pain, itself spoke from out of the heart of nature.

—Friedrich Nietzsche, *Birth of Tragedy*

We often find ourselves affected by a sprawling canvas or towering sculpture without ever having decided to attend to it. By their scale alone, such objects change the space we inhabit and then us by extension, an almost physiological consequence of being in their vicinity. A small-scale work, on the other hand, reveals itself only to a concerted gaze. One must make an effort, approaching, studying, even *entering into,* rather than being overtaken by, the piece. The unimposing miniature must ask for this commitment before it can have any effect at all. Is it not then, from the outset, obliged to make good on the viewer's investment, to compensate him or her for the time and energy necessary to devote to it? Miniatures are, it seems, always from the outset indebted.

And yet, rather than working hard to repay us with a presentation of beauty or fine craftsmanship, or with crude representational veracity, a small-scale work might instead receive the viewer's offering only to disrupt the economy of compensation altogether. Destabilizing the categories and distinctions by which one would observe, categorize, and evaluate it, such a work might undermine the currency of the exchange relation and perhaps even go so far as to trouble the distinction between the parties involved.

This is precisely what occurs when we decide to enter Peter Karklins' diminutive drawings. In each work and over the development of this series entire, we see contorted and partial human forms dissolving into or emerging out of a drapery of oozing body matter, pools of bodily fluids, and geological structures formed from heaped body parts. In presenting this vital and disturbing scene, these works effect a complex indeterminacy, for they are neither high nor low art, neither nudes nor landscapes, and ultimately they refuse even to be objects viewed by a subject.

These are tiny works of pencil on paper, materially base and worthless. They are also, however, meticulously worked, obsessively or almost manically so, the drive and intensity of the artist palpable (and even documented on the works themselves), as though he were laboring away on a masterpiece for the ages: unassuming, but self-assured, driven, even necessitated, as works of art surely should be.

Moreover, the subject matter here is also profoundly unstable. Seeming to situate themselves between nudes and landscapes, these works explode the human form into an environment, a world. Or perhaps a writhing sea of organs, parts, and fluids congeals into a human form. Even this is undecided; there is only the play of genesis and decay.

A traditionally rendered nude, by contrast, *exposes itself.* That is, to the risk of becoming a lifeless object, a still life, a thing finished off by the firm and final

strokes of the artist's hand, then possessed, assessed, and thereby exhausted by the scrutinizing eye of the viewer. Here in Karklins' works we find no such focus and no such finality. In this purgatory of snaking organism, something winks out here and there, but remains hidden. More and less than the nude, we are subjected to its formation and its deformation.

And a landscape, not a representation of any *thing* at all, has as its real task the generation of a certain fictional point of view. It is a false horizon that newly situates the viewer for a moment. Landscapes thus avoid the risks of presenting a focal object to be resolved and mastered, but in embracing the viewer too familiarly, there is the *seduction of transport*— you are there. This imaginary displacement can be pleasant, but it can also leave the viewer intact, the same but elsewhere. More and less than landscapes, Karklins' drawings encourage us to lose ourselves in a consuming kinetic field.

That is, leaning in, bringing ourselves close to the writhing surface, we are frustrated in our desire *both* to identify an object *and* to take up a secured subject position or point of view. We are, in suffering this crisis of representation, brought into immediate contact with the constructive and destructive movement that is so menacingly at work in these small drawings. Indeed, looking in this way, necessarily so near to the surface, we cease to look at all, instead beginning to touch and be touched, these forces and drives involving us, penetrating us, *even disintegrating and reconstituting us.*

We have not seen, or—better—we have not felt, this before. Of course, associations drift in, always in danger of becoming a secondary and thoughtless means of evaluation, and our mind wanders toward Dalí's melting otherworlds or Bosch's monsters. Here to Goya's child-devouring Saturn and there to Blake's more tortured human forms. But art does not repeat itself and remain art, and so such mapping of influence in no way interests us. These works run deeper, and we might try simply to feel the pulsing life that is set loose here. Disturbingly wild and elemental life, yes, but perhaps even the quotidian world is more like this than we wish to admit. Neither representations of reified human figures nor small windows opened onto another place, these works instead push back for a moment the comforting veil of familiar forms, discrete and identifiable, which usually populate and order our experience. They reveal then a certain underlying violence, an ever-flowing process of emergence into appearance and withdrawal into concealment, of generation and degeneration. What we might be exposed to here is the active underlying source of life as we presume to know it and the passage into and out of the human that we ourselves presume to be.

Art as Alibi in the Age of Surveillance
Malek Moazzam-Doulat

opposite

finding space to record the time
Jonathan Lahey Dronsfield

Once invisibility haunted everything. Today, it is a practical impossibility. Someday soon, it will be a crime.

Power—in forms great and small, centralized and dispersed—abhors the invisibility of its subjects. Power wants to see. Privacy (and rights are all, originally, a right to privacy) is strictly the prerogative of masters. It is a ban, a territory in which one is master, free from the exercise of another's power. Rights are a response to the recognition that visibility is a trap. The Domesday Book, that technology of surveillance deployed by the Norman conquerors, was met with resistance and curses from lower lords and barons who discovered that to be surveyed, and to be surveilled, placed one directly in the king's machinery of power and extraction. The Magna Carta followed. But it was doomed.

Privacy, it turns out, was only a historical accident of the limits of our technologies of information and control. Over time the areas too dark to govern, the people once too hard to reach, have been steadily conquered by census, then by file, and then by immense database, but also by the decentralization and multiplication of the loci and reasons of surveillance. Privacy was just our name for those still-dark places. We are now wholly enmeshed in intersecting lines of sight. In the digital age, we have abolished our privacy. We compel ourselves to bare ourselves everywhere, absolutely— we offer up our personal data, transactions, and movements, which are precisely recorded, parsed by sophisticated algorithms, and stored spectrally for instant recoverability and accessibility. The logic of our

age demands that anonymity and invisibility be abolished. And we accede. Soon privacy will be not only indecent but also against the law.

But what then? We will all have to become artists, for when we are called constantly to appear, art will be our only alibi. We need an art that is a machine of effacement. But if invisibility is impossible, then it must be an art of lies, an art that effaces through hypervisibility. Karklins as liberator.

Karklins' art is a profusion of lies (cat. no. 14). The apparent naturalness and organicity is pure artifice— a kudzu machine for the replication of forms. This multiplication of shapes is art not as simulacrum of a real, but rather precisely as the effacement of each form by endless others, rendering each one meaningless, denying the individuality of any figure.

The unbounded series of time and place coordinates parodies the Cartesian precision of the digital age. They are database countermeasures and false positives that sabotage the technologies of surveillance not by privation, but instead by hypertrophy. If the truth of the traditional work of art is supposed to be accessible via the gallery card that tells us who, where, and how, Karklins erases all of that, himself, and the truth of his art, by recursion, by overwriting.

In doing so, Karklins shows us the only remaining possibility for freedom.

One of the things that Peter Karklins' pencil drawings repeat is the pencil itself. If Robert Walser's penciled microscripts taught their writer to slow down so that he could begin to learn to write again and as if for the first time, then Karklins' pencil system, of no less colossal proportion and equal in magnitude to Walser's, has afforded the artist a certain patience. It is a patience with which to intensify the shading that only a pencil can carry out, but one that he has discovered in the movements to and from work and the micro-movements of the closed space of that work. Then is the material circumstance of the drawings the law of their reduction; is it because Karklins perforce could only make his drawings on the move or in the gaps of his "day job" that he is obliged to work on small pieces of paper, and to such excess? Or is it that he possesses the insight that perceives a possibility of this world that would otherwise go unseen, namely that the time and space of such days rather than what happens "in" them are the material for the life of an artist? But this possibility, the possibility in all its priorness and the priority of this possibility, has to be revealed or invented, but in any case made. We are talking about a possibility given not simply by what the artist draws but by how he does so. Karklins meticulously records the dates and times and sometimes the locations at which he calls on the paper. These visits are the very folds of what is drawn there and the impenetrable darkness of their shading. The dates and times make explicit a sort of presence. Yet in the forms of the drawing they withdraw as dates and times. What do we see or rather sense in this play of presencing and withdrawal, in the endless oscillation between Karklins leaning back from his paper to turn it over for the inscription of the precise time and date of the latest retracing, in these turnings of a singular page front to back day after day sometimes two or three times a day but usually only on one instance on any one day, often on consecutive days, to be meticulously recorded on trains, in bars, or alone at the desk? We feel the exchange between de-positing and ex-positing, the material sense given by the pencil lead depositing itself as a surface, and the exposited senselessness of ordering and recording what can only be outside of the picture: the dated and timed moment at which the material mark was made. Or, in other words, we sense the rhythm of the existence of an artist—the temporality of a back and forth, a front to back and back again, as the very structure of the artist's life. And it is this rhythm that makes of Karklins' works compositions, the compossibility of deposit and exposit. And if these registerings of time, these clockings-in-and-out of art practice, sometimes appear in the space of the drawing, in a whiteness produced by the intensifying of the life of larval forms at once figured and defigured, it is because this white, the blank unfilled, gives space to what is outside of the picture, but an outside no less original than that which is pictured. The white, the blank, is the space of the train ride and the hours on watch, and these are not simply pre-given, they have to be produced in and by the work itself. If most of the drawings in which the clockings-in-and-out appear on the front have no record of inscription on the back, it is because there is no clear "front or back" to Karklins' compositions; if anything, the front of these drawings is of the back. On the other hand, while Karklins sometimes states "this way up," he does not say "this way front." Moreover, he states "this way up" even when the written timings and even his own signature imply which way is up. So we must not presume that the writing has the representational status of what is drawn. Nonetheless, we can accord the writing a signification no less important to what we sense in these drawings than the bodies figured and defigured in them. It is also a corporeal signification, but the body is that of the artist. For it is a gesture, it is the gesture of turning the page and finding space to record the time. Finding space to record the time is the gesture that remains both before and after whatever it is that Karklin draws.

Das Innere der Zeichnung
Peter Trawny

In diesen Zeichnungen —das Erscheinen. Ein Moment des Erscheinens. Erscheinen ist ein Zur-Erscheinung-Kommen, in dem alle Phasen der sich formenden Materialisierung durchlaufen werden. Erscheinungs-Phasen, die wir ohne Ziel nicht denken können. In Karklins' Zeichnungen aber gibt es kein Ziel. Es bildet sich Gewebe, das weiterwächst zu Formen, die sich zuletzt dem Ziel einer bekannten Form entziehen. Metastasierende Gewebebildung, wuchernde Erscheinung. Vielleicht Natur.

Manchmal erreicht die Erscheinung die menschliche Figur. Dann wird die Atmosphäre surreal. Die Figur festigt sich nicht, sie bleibt vom Wuchern des Gewebes, dieses Schleims, berührt. Sie kann sich nicht vollenden oder ist vielmehr immer nur die, die sie ist. (Die Erscheinung geht über in den Schmerz.)

Zu berücksichtigen ist auch der Bildträger. Mehr oder weniger kleine vergilbte Zettel, deren Rückseiten beschrieben, be-zeichnet sind, beschrieben mit eigentümlichen Daten und Nummern (hat die Erscheinung ein Datum?), mit Namen, der eigenen Signatur, häufig mehrfach, mit einem Pfeil, der die Ansicht des Blattes definiert ("up ↑"), auch mehrfach, und—Namen von Komponisten, Titel von Werken (ich spreche hier vorzüglich von Zeichnung *6.30.03*, cat. no. 19).

Musik—so wird einmal Bruckners Neunte Symphonie erwähnt—Ist auch eine Zeichnung, eine unsichtbare Ton-Zeichnung. Gerade Bruckners Symphonien zeichnen den Weg von der Gewebebildung zur Erscheinung der deutlichen Gebärde. Man höre nur einmal den Anfang der von Karklins erwähnten Neunten.

Das Auftauchen von Gewebe, von Fleisch, vegetabil, spermienartig, sich verdickend, zusammenziehend. Keine Regelmäßigkeit, beinahe ein Geschwür. Und doch bleiben die Erscheinungsrichtungen klar—"up ↑." Aber - manchmal wusste auch der Zeichner nicht recht, und er korrigierte—"← up," nein, "up ↓"!

Musikalische Zeichnung, musikalische Gewebe bleiben nicht in der Notation, nicht in der Partitur. Sie heben sich von ihr ab und lassen einen Raum entstehen, einen Klang-Raum, der den Körper affiziert. Bruckner ist ein Komponist des Raums. Doch der Raum ist kein Zimmer, als hätte er Wände, keine bloße Oberfläche, sondern eine Sphäre, die ein Gewebe ist, Gewebe-Sphäre. Er ist keine Leere.

Dieser Raum wuchert also. Und es braucht nicht erwähnt zu werden, dass er nicht vor, sondern um uns ist. Wir sind in ihm.

Ich sagte, das geschehe in der Musik. Seltsam—bei Karklins geschieht es auch. Die wuchernde Zeichnung verlässt die Oberfläche. Es geschieht auf beiden Seiten des Zettels, mehr noch auf der einen. Das Gewebe geht über sich—und uns—hinaus. Erscheinen reißt schon Erschienenes—uns selbst—in sich zurück. Wie Licht.

Und dann steht da auch einmal "psalm 121," seltsam fremd unter den wuchernden Daten und Ziffern. Er beginnt mit dem Vers: "Ich hebe meine Augen auf zu den Bergen. Woher wird meine Hilfe kommen?" Erscheinen reißt schon Erschienenes—uns—in sich zurück. Niemand weiß, was dort im Innersten der Erscheinung, der Zeichnung, geschehen wird.

Peter Karklins, Art History, and the Question of Politics
Paul B. Jaskot

Peter Karklins' obsessive and overwhelming drawings play with imagery and techniques that are simultaneously seductive and hopelessly obscure. They open themselves to multiple associations, provoking a reaction that draws on their familiar yet strange imagery. For the art historian, such a provocation raises the question of what status these works have in relation to other moments that the artist may reject or embrace. Karklins is part of a visual culture of representational and psychologically imbued approaches to art. At the same time, he asserts a radical subjectivity that disrupts that historical dialogue.

Most noticeably, the birdlike forms that populate his works play off of the similarly organic but impossible bird forms of Max Ernst, the noted German Surrealist. Ernst began to develop his interest in birdlike forms by the mid-1920s, at the same time he began to experiment with more random and obscure techniques. With his development, for example, of frottage—a method of rubbing on paper or canvas placed against an object, leaving a pattern—Ernst also brought familiar organic imagery like tree bark into unfamiliar and thus nonsensical narratives. For Ernst, as for Karklins, the project was meant to draw the viewer in with certain kinds of expectations and then frustrate any clear response to those expectations. Indeed, Karklins himself has noted how he identified with some elements of Ernst's biography, including their shared Germanic origins. He was strongly taken by Ernst's 1961 Museum of Modern Art retrospective, which toured to the Art Institute of Chicago.

Ernst's project developed with his affiliation with the Surrealists, a group of international artists centered in Europe who aimed to combine Marx with Freud in compelling imagery. For the Surrealists, the exploration of the psyche was not only an attempt to assert the individual subject in an increasingly mass society. Rather, such psychological imagery was meant to rupture, to shock, bourgeois audiences through imagery that defied explanation. For Ernst, this was a political act, confronting a marketplace with objects that did not fit. Hoping to jar the viewer's expectations loose, Ernst's work asks you to see the world in new ways and to break free from the standard visual, political, or capitalist narrative.

The clear connections to institutional politics of the Left and a serious critique of culture had real play in this historical moment. Given, however, the current cynical turn of the majority of the artistic establishment as well as the postmodern critique of "authentic" politics (how many artists today, after all, want to be "trapped" in what they perceive as a mere label like "Marxism"?), the critical gesture in the art market seems hardly possible, at least at the level of structural critique. In this Karklins is also of his moment: his images do not raise the institutional issues of Ernst's, but rather assert the fragmentation at the heart of the status of the contemporary subject. Such fragmentation refuses a stable meaning imposed by market forces, but dynamically, it also rejects any attempt to engage and change that market. The depoliticization of art rests not on the continued claim of artists to radicality but rather on the absorption of artistic critique in a celebration of pluralism, a stance that is hard for almost any contemporary artist to avoid. While one can and should celebrate the subject and her or his autonomy, perhaps it is time to find a systematic and systemic critique of culture and its politics elsewhere.

Tracers
Elizabeth Rottenberg

Karklins uses his pencil like a knife. He inscribes his images on the page, pressing so hard that his paper becomes brittle. One may wonder whether Karklins is not forcing consciousness into the depths of our thought processes. But no, consciousness remains where it is, and so does the unconscious. Instead, Karklins draws intermediate links: leaving visible trails (literal dates, times, and places) as well as different light intensities that signal to us from behind the creepers. In Karklins' silent, pulsional world of visual thoughts—I will call these thoughts "tracers"—an unmistakable fluorescence comes to illuminate this otherworld for us.

What do we mean when we say that we are "making something conscious"? How does the transformation from unconscious to conscious come about? How do we arrive at a knowledge of the unconscious? It is of course only as something conscious that we know the unconscious, after it has undergone a transformation or a translation into something else. Karklins' drawings show us that such a translation is still possible. But that is not all: they also help us to remember that the repressed does not encompass the whole of the unconscious. The formations, stalagmites, and embryonic structures that inhabit Karklins' drawings make visible the topographical features of a much more inclusive—indeed an all-embracing—unconscious in which trace elements of the repressed (floating buttocks, disembodied breasts, penislike protuberances) are but its most obtrusive parts. Rather than lingering on these elements or being titillated by them, Karklins instead offers us a fuller vision of the unconscious, a vision in which surface and depth, organ and organism, human and mineral life become indistinguishable. If it is true that the repressed is the other of consciousness—that is, the other of our autonomous ego—then Karklins' unconscious topographies remind us that consciousness also has another, more archaic other.

Karklins thinks in pictures, whereas most of us think in words. Thinking in pictures may remain truer, more faithful to archaic unconscious processes than thinking in words does. In some ways, too, thinking in pictures brings us closer to the materiality of our dreams.

Like dreams, with which they share an archaic heritage, Karklins' drawings are like the stars before the light of the sun.

Some Reactions to the Drawings of Peter Karklins
William McNeill

In the work's setting up a World, it sets forth the Earth.... The work thrusts and holds the Earth itself into the openness of a World.
Martin Heidegger, "The Origin of the Work of Art"

The work of art does both, says Heidegger: it sets up a World and sets forth the Earth. Yet here, in the drawings of Peter Karklins, the World is barely there. It is obscure, inapparent—if it is there at all.

A world, no matter how finite, is always expansive, an opening up, the opening up of broad sweeps and soaring heights, above ground, the setting up of manifest yet distant horizons.

Yet here, in these drawings, the scale is minute: Look closely, *lose yourself in this...*

Bodies distended and deformed, contorted-distorted, androgynous figures, fetal forms, mutilated; monstrous deformity, dissolved-dissolving into primal slime; progressive liquidation, dissolving the human/animal distinction; skulls peering out from darkness; eyes, at times indistinguishable from other orifices; continual movement, serpentine, winding, snaking, at times melting into the flow of hair, on occasion a sudden plunge; sperm, dissolving into tears, dripping, as in stalactites; cavernous, cavernal-nocturnal quality...

These drawings are primitive, primal, prehistoric—they reach back before the time of a world. Like the tracings of flows engraved on a rock face, that of a cave, perhaps. Yes—cave drawings: they have that cavernal, cavernous quality; they belong deep underground, in the darkest chambers and hidden recesses of the Earth. It is to there that they tend,

from there, no doubt, that they emerge, through what Nietzsche once called the volcanic flow of the human imagination. The lava flow congeals into these works, as they make manifest the ultimate coalescence of the movement and flow of all life, of everything living, wending and winding its way through the porosity of life.

Conjecture: These drawings are about one thing—descent. The descent of life, as in its provenance from the ultimate concealment that the Earth itself shelters; yet also life's descent as its history, its meandering, in twists and turns, through the world, the path it will one day, in retrospect, be seen to have taken; finally, life's descent as its going down, its cascading, downward plunge toward and into the ultimate abyss, its return to that concealment from which it once emerged.

All Earth, too much Earth. And yet—as we teeter on the verge of losing ourselves entirely, just as the Earth threatens to engulf us—some of the drawings, at least, pull us back from the edge of the crater, back into the time of a world, of someone's world, of a history: *Street Sept. 16, 99 7:26 A.M.; TRAIN @ 9:35 P.M.; Oct. 1, 1999 2:23 A.M. office; 3-10-00 @ 3:25 A.M.; TRAIN 9-24-99 9:40 P.M.; office 11:54 PM; SEPT. 23, 99 STREET A.M....a human-to-human bridge?*

À la Karklins
Pascale-Anne Brault

L'artiste en son sein
la poitrine, *pectorina, pectus, pectoris, thôrax, stêthos,*
cage thoracique, buste, torse, tour de poitrine,
l'artiste en stéthoscope, gorge, sein, globe, pointe,
mamelon, aréole, néné, nichon, robert, poitrine
basse, tombante, en poire, forte, opulente, généreuse,
abondante, plate, plate comme une limande, poitrine
ronde, pleine, ferme, belle poitrine, poitrine haute,
pigeonnante, seins distendus pendant vers le bas,
seins qui pointent vers le voyeur, sensualité des
rondeurs, en pomme, fesses et seins indistincts,
agglomérés, surgissement de seins qui affleurent,
à fleur de sein

L'artiste en tripier ou boyaudier
intestins, *intestina, entera,* êtres intestinaux,
viscères, intestin grêle, duodénum, iléon, jéjunum,
gros intestin, valvule iléocaecale, caecum, côlon,
rectum, anus, enveloppes : muqueuse, tunique
musculaire, tunique conjonctive (mésentère),
vaisseaux chylifères, artère mésentériques, veine
porte, péritoine, epiploon, circonvolutions,
villosités intestinales, les chairs telles qu'on peut
penser qu'elles le seraient à l'intérieur, dévidement,
éviscération des intérieurs

L'artiste en équarrisseur
masse, de dos, fesses, ventre, le tout en un, rocher,
bloc de pierre, empierrement du corps, pétrographie,
marque un jour d'une pierre, blanche, ou noire, stèle,
dolmen ou menhir, minéralité de la matière, une

demie-stèle, deux corps ? deux bouches ? érigées en
statue, soap stone, aspérité de la roche, amas, tas, pile,
souterrain, grouillement, vers de terre

L'artiste en liquéfacteur
liquides organiques, lait, larme, sang, sperme,
lymphe, chyle, suc gastrique, sucre intestinal, sueur,
salive, bave, écume, morve, mucosités, urine, coule,
s'écoule, ruisselle, dégoutte, dégouline, suinte,
filtre, s'épanche, se déverse, déborde, transvase, tout
s'épouse, se fond, se liquéfie pour s'enfoncer dans
la distance, du liquide en larmes qui tombe goutte
à goutte, fluidité, liquéfie, dissout, dissolution,
coagulation, dégoulinement de corps en flaque
inférieure, fuite et déliquescence vers le bas, le
dessin coule comme si sa liquidité allait quitter la
page, une fois, un corps distinct, chauve, sans doute
masculin, assis ou accroupi, duquel dégoulineraient
des corps de femmes, des pénis, des larmes ou des
mamelons, éjacule, évacue, défèque, mêlée, sous-
marine, houleuse, tumultueuse, friselis, remous,
ressac, raz de marée, alluvions

L'artiste sur des œufs
formes ovo dales, œil près du sein, membrane
vitelline, blanc, albumen ou glaire, ovaire, ovule,
ovulation, ovisac, ovogenèse ou oogenèse,
oocyte, oothèque, ovipare, oviparité, ovovipare,
ovoviviparité, nid, nidifie, niche, pond, ponte,
pondeuse, couve, couvaison, couveuse, incubation,
ovoide de femmes, gobe un œuf, étouffe cette
affaire dans l'œuf

L'artiste en pyromane

corps en flammes, flambe, s'enflamme, combustion, ignition, calcination, inflammabilité, ignifuge, embrasement, jaillissement, grisou, incendie, sinistre, dévore, ravage, consume, flambée, flamboiement, brasier, crépite, pétille, scintille, ardent, feu de joie, autodafé, pyrolâtre, Azer (feu adoré des mages), Guèbres, Parsis, Mazdéisme, Vesta, Mithra, Vulcain, Cyclopes, Prométhée, à petit feu, entre deux feux ou deux menaces, tout feu tout flamme, fait feu de tous bois, fais long feu, feu de paille, met à feu, mets le feu aux poudres, jette de l'huile sur le feu, donne le feu vert, le feu au derrière, lave en désordre, pète le feu, joue avec le feu

L'artiste à l'œil nu

histoire de l'œil, *oculus, ophtalmos,* yeux exorbités, dans la masse des chairs, des yeux, fixité de poissons morts, toujours un seul bloc, percés de quelques yeux, de-ci de-là, masse de poissons filant dans l'eau trouble, œil de cyclope, orbite, globe oculaire, iris, uvée, corps ciliaire, coro de, cornée, humeur aqueuse, yeux caves, saillants, globuleux, à fleur de tête, fait les gros yeux, écarquille, ne ferme pas l'œil, regarde d'un bon, d'un mauvais œil, saute aux yeux

L'artiste encorps

muscles saillants, corps décomposés, multiples, reconstitués en un, magma de formes, deux gueules de chien ? fusion en écorce d'arbre, fuite vers le bas ou le haut, des nombrils, des orifices, des vagins, des surgissements de fesses, marbrures, rondeurs, femme de dos, à même la terre, où sont les bras ? les têtes ? la femme réduite à la féminité, à son sexe, bouts de corps en pile, la rondeur de certains fruits, on en mangerait, on en toucherait, corps distendus, étirés vers le haut et le bas, entrelacs de branches, copulation, accouplement, corps féminin pourvu d'un pénis, corps par moments de squelettes, réduits, minuscules, amassés en tronc d'arbre, certains en position fœtale, échevelure de corps, sirènes et méduses à la fois, masse bovine, épaisse, touffes de poils noirs, on y distinguerait du végétal, de l'animal, voire un oiseau, grouillement, foisonnement pieuvresque, superposé sur un corps immense, souplesse des formes, on les caresserait, pas d'angles aigus, alignement, placement en réseau, structuration linéaire, mains, visage indistinct, chevelure, dieu maya, le tout ponctué de rondeurs, volcan en éruption, érupte, s'y remarqueraient peut-être des animaux, vertébrés ovipares au grand bec, repliement sur soi-même, superposition, foule, multitude, armée, légion, comprimés, entassés, compressés, foultitude, une foule de petits corps qui soutiennent des fesses, rangées en ligne, cubiques, un grand corps de femme, replis de la chair, main qui vagabonde, plis, replis, recoins, corps échevelés, on les enculerait, caverneux, imbroglio des corps, pluie de pieuvres, foule de spermatozo des, promesse de la procréation, verticalité du parcours, rideau de fibres, chute libre, grouillement, tourbillon, attraction du centre, déferlement, courants contradictoires, racines filandreuses, jambes, vagins, vulves, utérus, arrondis des seins et des fesses, truculence, décha nement des formes, distension des corps, pluie, chute, mise à feu, mise en scène de l'érotique, distendu, métal repoussé, affolement des courbes, enchevêtrement, plusieurs directionalités, encombrement des pages, poussées telluriques, converge, texture de troncs d'arbre, métallique, cotonneux, transfuge, éruction (note au dos : Analysis = paralysis), pointillisme, fauvisme, le sexe faible, fort, le beau sexe, exhibitionnisme, libido, érotomanie, nymphomanie, satyriasis, masturbation, onanisme, reproduction

All Day, All Night
Dolores Wilber

nature → art

Returning to the Body
H. Peter Steeves

Reader, so God vouchsafe thee fruit to get / Of what thou readest, think now in thy mind
If I could keep my cheeks from being wet / When this our image in such twisted kind
I saw, that tears out of their eyelids prest / Ran down their buttocks by the cleft behind.
Truly I wept, apposed upon the breast / Of the hard granite, so that my Guide said:
"Art thou then still so foolish, like the rest? / Here pity lives when it is rightly dead.
What more impiety can he avow / Whose heart rebelleth at God's judgment dread?"
—Dante Alighieri, "Inferno," *Canto XX,* lines 7–30

Man has no Body distinct from his Soul; for that called Body is a portion of Soul
discerned by the five Senses, the chief inlets of Soul in this age.
—William Blake, "The Marriage of Heaven and Hell"

Reason, thou see'st, hath all too short a wing.
—Dante Alighieri, "Paradiso," *Canto II,* line 57

Twentieth-century philosophy is marked by a series of returns: to the things themselves, to the world, to our embodiment in a world of things themselves. It is, as Eliot reminds us, a return that allows us to see the point from which we embarked for the first time. To ask, "What does it mean to be human," then, brings us back—back to our fleshy being, to our premodern selves in all of their carnal-spiritual nondualistic glory, and back, as well, to the neo-realization that embodiment is hell.

Peter Karklins' disturbing, and disturbingly enthralling, pencil sketches read like miniature details of a David Cronenberg storyboard for a film project chronicling H. R. Giger channeling William Blake commissioning a zombie version of Auguste Rodin to sculpt the New Gates of Postmodern Hell. Bodies sit in and inhabit a desolate world in Karklins' earliest works. Later these bodies become the world; nano-corpses bond together to form a microscopic view of the body as a whole. Veins and ligaments emerge, repeating the shapes of the macro-body, and the possibility of the subject—a possibility already being called into question in the earlier works in which landscapes and portraits merge—is denied.

No subject; no subjectivity; no centrality to let the viewer's gaze rest and find comfort, find home, return, discover *the whole.* Intercorporeity is not a promise; it is a threat. *Dasein* is being eviscerated. This is what it sometimes means to be human.

Every work of art carries with it the mark of its production—the mark of the beast of burden that brought it into existence, the economic, social, cultural, sexual stamp of that fictional subject we call "the author." In Karklins' work, part of the aesthetic object is the meticulous log of its production: it is a cataloging of the moments of its coming into being, the author clearly marking the work of art as an event rather than an object as he records the *where* and *when* of each instant he works on the piece. When the world gets more microscopic, this log is forced onto the back of the paper, though rather than thinking of it thus, we should see this move as one that acknowledges that the back was always already central to the art. For just as the body is being fully exposed on these small pages—front becoming back, inside turned outward in a fantastical topology of flesh—so, too, is the work of art exposed and made fully present here.

We are, in a sense, with the artist in these moments. But like all of Karklins' intimacy, it is a morally and aesthetically complex relationship into which we are invited. Bodies are exposed, it is true, with the curve of sex organs and the occasionally foreboding orifice forcing us to ask after the sexual politics at work, the manner in which the dismembered and displayed female body necessarily carries a value different from the male's. But it is the necessary manner of viewing these works that raises the real question here. From a distance, patterns of dark and light emerge, which some would surely find interesting, but the artist demands we get up close to the art in the end. He demands we get up close to him.

Here, at this short distance, our bodies threaten to mimic those on the page before us. We see the minute lines and erasures that form the systematic madness of torture. We feel someone's breath on our face as the pencil traces the desire, delirium, and disturbance. We pull away, wanting to punch out, to leave our date and place and time on the log, move to the next circle, and be done with all of this. Even as someone calls us to return.

The Creation of Wilderness

Ryan Feigenbaum

In Peter Karklins' untitled work completed on January 17, 2000 (cat. no. 5), we immediately notice the formidable eyes of a creature ensconced in the trees of an old forest. The moonlight inflames the *tapeta lucida* of these eyes that stalk us like those of a nocturnal predator. But these eyes belong to no recognizable animal, for this upright creature appears to gaze from behind a mask. As we stumble through the nighttime of this forest, trying to find our way along its streams, among its pines and oaks, stones and shells, a possibility surfaces: this creature, in whose eyes wildness and rapture carom, is a maenad, insatiably possessed by Dionysus.

However, neither nature nor the mythical is represented here, since true entrance into the drawing requires transport to a terra incognita; in fact, we slog, not over the loamy ground, but through bodily fluids, putrefied and menstrual. Those streams? They ooze with slime. Those trees? They are bedizened with human genitalia. Those stones? They are dissevered breasts. This forest is constructed from bodily forms that have been stretched and contorted, severed and rearranged. An anxiety pounces. Must the explorer within this drawing suffer the same fate as Pentheus? "His body lies in pieces, part under the jagged rocks, part in the green depths of the forest; no easy thing to find." In this strange forest, the familiar landscape has been perverted to such a degree that it becomes unrecognizable, making orientation nearly impossible. Any sense of direction or distance is confounded and then entirely collapses. In Karklins' created wilderness, we are irrevocably lost.

In his early-twentieth-century *Handbook of the Outdoors,* Earle Amos Brooks begins with an account of being lost, describing it as the moment in which all ordinary signs are thought to be awry. He explains this bewildering experience as when north seems south and streams seem to run the wrong way. This explanation suffices for hiking in the woods, but it must be amplified in light of these drawings; that is, being lost cannot be confined to signs that have gone awry, as powerful and unnerving as that might be. In Karklins' wilderness, being lost applies to signification itself. So the beloved is not just misrecognized as prey in the maenad's wild gaze; rather, the beloved cannot be recognized at all. Indeed, within Karklins' geographical perplexities, our senses are shattered—we lose our minds.

What is more, we find evidence that even the artist was not immune to losing himself in these works. To indicate the proper orientation of his later drawings, where the compositions have grown stunningly complex, Karklins has drawn an up arrow—but only on the palimpsest of several others. On one such drawing, this arrow is also accompanied by the sketch of a compass. It is not difficult to imagine that within the artist's wilderness, a moment came in which, without this cardinal sketch, he would have irretrievably lost his mind, his time and place.

These arrows, then, indicate more than how to hang the drawings properly, for they attest to the loss of signification experienced in Karklins' created wilderness, where entrance is granted only at the expense of obviating later emergence. We do not look upon these drawings, but peer out from beneath them.

This Dripping Life: Englobulation in the Nature Drawings of Peter Karklins

Andrew J. Mitchell

Nature is a dripping, coagulative affair. The drawings of Peter Karklins are nature drawings in just this sense. They show the fomenting movement of nature and our part therein. In a word, Karklins shows the *englobulation* of nature.

Nature knows no discrete bounds. It is end-less. How could what appears in nature not be pulled apart by this? An infinity of nature in every direction, the gravity of the situation would tear one apart. And yet there is a balance—the harmony of nature, a balance that is achieved at the price of isolated, discrete identity. Nothing is final. The moon pulls the tides. But it is not just the tides; the moon pulls everything and is itself pulled in turn. Without ends we are awash in this interminable middle of nature.

What materializes of this can only be a dripping globule. Πάντα ρεῖ. Everything drips. In Karklins' drawings, the englobulation of nature is underway. Dicks, tits, balls, and hips sway and fall over one another across these images. They coagulate upon each other, in compounded accrual. Lobes of flesh cascade and tumble over themselves. They are perkily buoyant against the forces of gravity, englobulated.

Not gravity as antagonist. These are nature drawings precisely by showing how the flesh belongs to the forces beyond it. The flesh is drawn along and this too can be drawn from the drawings themselves. Nature is the medium for englobulated appearing in all its gravity. Karklins shows the flesh under our skies, in medias res.

But in this Karklins is not alone. Another student of nature identifies the same englobulation. Thoreau's *Walden* culminates in the chapter "Spring," in which Thoreau witnesses the slow melting of a snowbank. The process leads Thoreau to a thinking of englobuation, with particular attention to the human body:

> What is man but a mass of thawing clay? The ball of the human finger is but a drop congealed. The fingers and toes flow to their extent from the thawing mass of the body. Who knows what the human body would expand and flow out to under a more genial heaven?

A different sky, a different atmosphere, and there would be a different body, as these are inextricable.

> The nose is a manifest congealed drop or stalactite. The chin is a still larger drop, the confluent dripping of the face. The cheeks are a slide from the brows into the valley of the face, opposed and diffused by the cheek bones. Each rounded lobe of the vegetable leaf, too, is a thick and now loitering drop, larger or smaller; the lobes are the fingers of the leaf; and as many lobes as it has, in so many directions it tends to flow, and more heat or other genial influences would have caused it to flow yet farther.

The dating of the drawings, the almost obsessive timing of them, only attests all the more to the impossibility of delimiting this naturing nature. Life drips past itself.

Flesh in Time

Karmen MacKendrick

This is what must be understood: the wave flows through the body; at a certain level, an organ will be determined depending on the force it encounters, and this organ will change if the force itself changes.... In short, the body without organs is not defined by the absence of organs, nor is it defined solely by the existence of an indeterminate organ; it is finally defined by the *temporary and provisional presence* of determinate organs. This is one way of introducing time into the painting...
—Gilles Deleuze, *Francis Bacon: The Logic of Sensation*

In painting as in music, it is not a matter of reproducing or inventing forms, but of capturing forces.
—Gilles Deleuze, *Francis Bacon: The Logic of Sensation*

"Analysis = Paralysis," a note on one of these images warns, and it is certainly easy to become paralyzed here, trying to figure out what to say about such rich pieces without going on forever. Paralysis threatens the images themselves, in their precise and obsessive detail, their erasures and returns. But against the paralytic risk is a stronger force, a disordering and very somatic urgency that unsettles any imposition of order—and introduces time into the image.

Time is a driving force here—time in text and time in flesh and so time in tremendous and urgent tension, encountering forces and changing organs and running the dual risks of rushing by too fast and coming to a paralyzed halt. The drawings combine a near-infinite patience of detail and precision, the obsessive impossibility of moving on, with the impatient force of desire as it faces time slipping, the urgent knowledge that we will be hard-pressed to pack so much carnal force into so little time. In every type of image here, with text and without, time and flesh run abruptly into one another, urgency intruding on order.

The most textual pieces offer neat lists of times, dates, places, with directive arrows telling us which way is up. Here are the elements of discipline, the where structured by the when, the combination telling us how to position our corporeal selves for maximum efficiency. But even here, contrary elements intrude. The directive "Up," appearing so often with other text and over images, sometimes holds flesh upright, sometimes leads us to read in the proper direction, and sometimes the arrow tells us to follow the image and not the text, which then appears inverted, rather thoroughly undermining our sense that these are the kinds of words that will set things in order. It is undermined, too, when the otherwise orderly text is crossed out, scribbled through, erased, and laid out at disorderly angles, or when mundane listings of train times, street addresses, and hours in the office are disrupted by phrases evoking religious revelation (*Gloria, adoration,* but also the crossed-out *spirituality* and *redemption*), forces of nature (especially those related to the sea and primal slime, but also forests, mountains, caves), and over and over the names of musical compositions. Religion, nature, and the Dionysian arts are exemplary disruptions, and they remind us that the order of time never quite stays disciplined; there is not enough time for it.

Where texts overlie images, it is the visceral quality of the drawings that threatens the tidy organization of words. In the images that combine pictures with bits of text, dates and times struggle for order in the margins. In the midst of that imposition of order, here are these forms, demanding; here is the chaos of an excess of flesh overlaid on and with the order of text. Art, we sometimes think, preserves its images, holds on to what would otherwise be lost; what is preserved here is the impossibility of preservation, the rich, thick, fleshly moment as mortality pulls it away. Here the force captured—demanding desire, chaotic excess—is in some measure its own resistance to capturing.

Short of time, the body is stripped to its essentials, the most necessary of its organs for conveying the most intense of its sensations. In the confined space of the page, these figures nonetheless become so full that they burst: in some a voluptuous roundness threatens the capacity of the skin; others, too heavy to contain, uncoil and drip slowly down the page. Voluptuous fullness plays off of overripe decay; we want *now*; we could soon be out of time. What could be an intestinal, stretched-out twisting could also be the happy decay-feeding worms—or the snake whose connection with old life restored runs at least as far back as *Gilgamesh.*

And because there is not enough time and yet so much desire, imagistic elements must do double duty. The sensation *makes* the sensing organ. A shape ambiguously phallic and gluteal repeats itself in a single and almost simple form; this pairing is what is urgent in this body, and to add in other details would only distort it, only lie about it. Things turn inside out as well as upside down: the rounded, dark-centered breastlike shape that draws our gaze could as easily be an eye itself, and this is no mere interesting illusion: a part so often gazed at suddenly looks back. We realize that dimpled finger-inviting orifices rather precisely invert glaring exophthalmic eyeballs, and the disturbing sexuality of the images becomes more startling still. Just as we were, however uneasily, indulging in voyeuristic pleasure, we are caught looking, reminded that we can be looked at too, and that too from disconcertingly close up, already drawn into near contact. We would back away, but there is still so much there that we want to see, in so little time, in such obsessive detail, before order once more makes its effort to intrude, before the urge to analyze, and not to sense so much, paralyzes us again.

This Side Up ↑
Michael Naas

03.03.09: Delimit your field, clear a patch of time, and stay focused for the long night shift. Journey far and wide across the page, but take pains not to go over the edge. Draw and re-draw, erase and re-erase, and repeat for thirty days—long enough to form a habit, build a habitat. Pile it up and peel it down—maybe even deconstruct. Draw it out and draw it over, draft upon draft. Pin your hopes on the palimpsest, the underwords and underworlds. Work the count, crowd the page, and stay ahead of the curve. Be careful that one hand does not erase what the other hand draws. Date and re-date, and let the sheet give rhythm to your life. Punch in, punch out, and record the hours of eye-sore and absorption. Bide your time. Let the page be a testament to the passing hours. Cross off the days and layer the graphite at a going rate. "Works and days" shall be the caption for each scene, whether "on the train" or "at the office" or "on the street." LINK the days and let the date of the art become the art itself, the signature the sign, the play the thing. Bring your world to work and cultivate your garden there. Make the bed with SKIL and sketch it out across SILK sheets. Tie your subject down not with indelible INK but lead that rubs and IRKS, smears and smudges. Start each as a LARK, done just for KIKS, since each will soon become an obsession, infinitely revisited and revised. Know that some will take weeks, some months, and some will be forsaken. Allow yourself to begin a second before the first is finished—a serial drawer one step ahead of the law. Series and serration: that will be the order of the day. From blank Fabriano ye shall fabricate a world. So zap the primal SLINK, the reek and RANK of aboriginal soup, and let the forms emerge from the teeming void. Let words evolve from the alphabet goop and then SINK back into incomprehension. You are the catalyst, the shock of raw; there can be no genesis without you. Take Fibonacci seriously. Follow the woof and warp of computer circuitry to account for contingency and the plastic whirl of π. Fashion forms from the primal ooze with earth and water and life infused, all fired in your KILN. Let the elements mix and match, the magma melt of monsters in mutation, goo-bodies in gyration, still lifes with polyps and protrusions, colon-escapades, masses living and lifeless in profusion, metalwork meticulously rot, rhizomes and roots, entrails spilled and spoiled, bodies smooth and squiggling, undulating forms of tongue and groove, eye and omphalos, galaxies swirling out in golden rectangles nanoseconds from ex nihilo. Let the neo-natals arise from "The Sea of Gloria," castaways from "The Storm of Being," bodies devoured and "Devouring," half-clad like "Gloria on the Beach." Then gather all the species on your ARK, the maggot-laced and their wiggly wormed KIN, the creepy crawling and their tunnel-visioned ILK, always the same but never identical. Let the tentacles pray in their "Adoration of the Earth Mother," or embrace on two different planes. Then SKAR the SKIN front to back to release the avatars of their low lives. Tag and trace them from dusk to dawn and be ready for apparitions in the chiaroscuro. SKAN the labyrinth for images real and imagined, portrayed and projected, for constellations in your milky way, insects in the weave, animals in the clouds, faces in the flow. Search the threads of the symploke, the layers and the layered, for human forms, drooping flesh and dripping breasts. Let your pencil shape and shade her, draw and withdraw from her. Let the eraser caress her, adding flesh unblemished to flesh defined and defiled, and then chalk it all up to ghost-lines. Let the pencil be your scalpel, the page your theater of operations: go in for a bypass and do cosmological surgery while you're at it. Travel the body up and down, the ins and outs of veins and vessels, arteries and aortas, cells and sinews, nerves and neural networks. Polish the cold stone flesh, the bare backs bowed in unnatural light, invaginated eve engorged in adam's apple, or mothers inclined to giving suck. Multiply the ambiguities: the flesh inviting KIS, the flesh implying IS, the bare S in the flesh—SINful and rejuvenating. Flesh of my flesh (SARKs)—take and eat it, you will say, in your name, you will say, till the host is cooked to taste. Then sign it on both sides and preserve it in a baggie to limit RISK of desecration. Keep it visible in prophylaxis and display your Book of KILS one page at a time. Make a show of yourself and draw it out, exhibition as striptease. And then lay low, like monk or scribe, for your drawing is your adoration, your gore your Gloria. Let the lines themselves proclaim "analysis = paralysis." Let "This side UP↑" be the onlooker's only orientation. And remember that you are no longer who they say, neither the RK nor the end, no longer the draftsman but the draft, torn asunder and under erasure, alone in your own company, incorporeal and yet fully incorporated, tread-marked like nobody's business as

K. SARL INK ®. Michael Naas © 2009

Neither here nor there–the man who captures motion

Liam Heneghan

It was at a little café on Webster. Every so often I glanced at the artist in our company: one of those young fellows for whom the past is not a burden and who care not a whit about the future. He was frustrated by our unwillingness to pose for him. His pencil worked the paper tablecover—he listened but did not participate in the conversation, and all the time he was adding his marks on the makeshift canvas as if capturing the exchange. When we got up to leave, I examined the work—he had drawn our group over and over again in a way that seemed to gain possession of movement. "Kinetic art," we christened it. That artist developed the technique no further; I hear that he is a mathematician now.

People move, nature riots, the earth spins, the stars fall in the void, and yet a single remarkable thing can stop us in our tracks. Motion and stillness, passing through and settling down: the poles of our animal existence. The philosopher Edward Casey has argued that motion and stasis bracket the dimensions of dwelling. Hermetic dwelling, with the very wings of Hermes on our heels, propels us through the streets of our hometown. Hestial dwelling has us curled up back at the hearth. We need buildings and we need thoroughfares—places to rest and routes through which we can flee.

Let me make a bold statement: the visual arts have been more innovative with the Hestial forms of dwelling, where the mobile artist and the restless object are toned down to mere vibrations: the flick of the pencil, the casting of the brush upon a canvas, the

landscape quelled. Quelled even in a Turner where an isolated frame proclaims the tumult of it all. Even the first artists, dwelling transiently in the snug of a cave and depicting the frenzy of the hunt, commemorate (or anticipate) only moments of that commotion that percusses from a world antique for multiple millenniums. Is the problem of Hermes just less interesting to us; or is it more difficult to innovate with motion? Not the former surely, as Hermes' problem is Aristotle's own. In the *Physics,* Aristotle even defines nature as a "principle of motion and change"; for him, knowing that we understand motion is critical for a claim that we know nature. Representing motion on the page, on the canvas, on the wall, must be, as they say, much easier said than done.

Not that there are no innovations. My artistic breakfast companion mentioned above, it must be said, had a small genius for this, and though I kept the piece he had worked on that morning on Webster, the work was more interesting than beautiful. The work of Roman Opałka illustrates another, more celebrated, approach. Opałka famously died, one can say inevitably died, during his attempt to paint infinity. This series of "details" is called *1965 / 1 – ∞,* in which the artist painted numbers in white, on a gray background, the numbers fading as the paint dried on the brush.

I have been carrying around several images by Peter Karklins over the past year or so. In motion on my hard drive; in motion in my recollection of

them, having been shown several small works by a friend one evening in the Gaslight Bar on Racine. The images arrested me. Karklins' work can be considered a successful resolution to the difficulty I am describing here—that of crystallizing motion in a way that is as terrifying as any honest attempt to capture dynamic nature must be (recalling Opałka's last painting was of the number eight). They are beautiful, for if it is nature, it must sooth as well as scorch, and they are performatively successful in the way that an eye is terrifying in it complexity, beautiful in the gaze of our beloved, and successful in the synthetic marvels it performs.

A central innovation in Karklins drawings is that time, motion, and the work that culminates on the surface are recorded not just in the terror and beauty and performance played out on a tiny canvas, but is quite literally recorded on the back of each piece. A series of dates and locations provides a record of Karklins' movement across the city; recorded as our Hermes makes his journeys and creates his fire. Turn over a Karklins and see what is there: it's as if one were to reverse an Opałka "detail" and discover that behind the numbers there is something there other than death.

Resounding Depths:
Peter Karklins' *In the Deep*

Ashby Kinch

Peter Karklins' hand is a seismograph, scratching out a miniaturized register of an energy released by a geologic rhythm that appears in his drawings in the earthly form of hills, caves, lagoons, and caverns that together create an emotional geography. Occasionally, a heavy border of lead stops short of the edge of the paper, revealing a hidden layer beneath, like a sedimentary rock whose top layer has been shorn off by a powerful force, allowing us to peer into the subsurface.

But the better geological analogy for his drawings is the cave, that space of prehistoric creation where humans first attempted to understand the working of their own minds by projecting onto stone walls, under the flickering light of a torch, an echo of their mental apparatus. Like the drip of water from the roof of a cave, Karklins' process, scratching out carbon onto paper, produces accretions that shape into forms, particularly forms of the nude female body, though one discovers the shapes, makes them appear, precisely as a visit to a cave produces the desire to turn the contours into coherent objects of vision, to stabilize our sense of self in an alien space by exerting the authority of the name.

One can get lost in these drawings, again an effect of the cave, the lines of overlapping space moving the eye along multiple simultaneous contours. The disorientation of the spatial register is occasionally resolved on the verso, where a simple spatial direction—"Up" with an arrow—tells us where we

are. Space is visually marked in the accretions of carbon, and then those accretions are often told on the verso in the form of temporal markers, giving the exact time in which the drawings were executed and sometimes even corrected for precision, as on August 23, 2001, when 5:35 a.m. was changed to 5:38 a.m. It is as if the artist knows we need a temporal anchor, that in the cave, beyond the light of the sun, our temporal grid threatens to vanish, to release us into the ebbs and flows of our unregulated bodies: with the circadian rhythm occluded, time can stretch elastically and compress violently in ways that obliterate the clock.

But the drawings mark time in a different way as well, through their music: one can hear a Karklins drawing, a synthesthetic potential embedded in the rhythmic technique of the lines themselves, which are audible scratches on the page. But one can also listen along to the aural environment in which the works have been produced, the music that animates his art: on the back side of his drawings, he has left behind a soundtrack. In one particular drawing, which bears the phrase "In the Deep" (cat. no. 13), we hear no fewer than six musical compositions: Gregorio Allegri's *Miserere,* Schubert's *Trout Quintet* and *Death of the Maiden,* Britten's *Variations on Frank Bridge,* Dvorak's *Serenade for String,* and Borodin's *String Quartet No. 2*. Against the regulation of clock time, the music provides a rhythmic time for the eye as it passes over lines that build on one another and recede like the themes and counter-

themes, swails and dips in a gusty passage of music, like the frenzied end of Borodin's *Second String Quartet in D-major,* which builds and relaxes, builds and relaxes, replaying in miniature with punctuated recapitulation the composition's major themes, dramatically re-creating with increasingly greater speed and intensity the sweep of the whole.

The earliest date marked on *In the Deep* is January 9, 2001, and the latest is April 24, 2002, a space of over a year, though the drawing was produced in fits and starts, in bursts of energy we might say, and through a process of revision. Indeed, it was "completed 8.24.01" according to one notation, under the spell of Dvorak's *Serenade for Strings,* but not "corrected" until January 16, 2002, when presumably the associated phrase changed from "The Summit of the Mountain in the Cave" to "In the Deep Green Lagoon," before taking final form as "In the Deep" on January 24, 2002, while Borodin's *Second String Quartet* played its way through the artist's hand. The change of titles and the shift of places corresponds to a fascinating perspective on his work, where caves, lagoons, mountains, and oceans all share a space with one another, morphing into one another, their altitudes and breadths becoming metonyms for their various forms of depth, of recession that marks the recesses of the human mind. And note that the big gaps in calendar time are punctuated by bursts of energetic creativity, much of it performed in the deep recesses of night—2:29 a.m., 4:30 a.m., 3:50 a.m. on consecutive nights.

That word "deep," associated with the depth of both waters and caves, gives us the entire sweep of the drawing, which began at a summit and plunged into a lagoon, before settling for a depth on two axes, both lateral and recessive, as well as vertical and bottomless. The drawing thus plays out the tension between clock time, mechanical and calculating, and the subjective time that music induces, driven by rhythms that dissolve that regulation into the shifting intensities of emotional and psychological life.

In the cave of Karklins' drawings, our eyes are best used as hands, groping for some elemental truth, or as ears, listening attentively, with the nervy edge of anxiety that always accompanies an experience of the dark, listening for some revelatory sound.

Gloria...For Peter Karklins
David Farrell Krell

Breasts—if that is what they are—can never be too much in evidence, nor too little. One craves both. If the craving be denied, one winds up like Hegel or Hegel's spirit, who hates the breast: after nine months of umbilical concatenation, the human infant is slapped right onto the mother's breast and where is freedom? Woman is the one who conceives, Hegel says in his Jena lectures on the philosophy of nature, but she does not conceive philosophically; worse, she is "*digestion* turned to the outside," like a mother bird vomiting aliment down the gullets of her brood, confusing incretion with excretion. She incites everywhere, especially around us men, a "metaphorical surrendering of heart and soul to the woman," but she is not worth it. Woman "remains in her undeveloped unity," Hegel says. She isn't going anywhere. She is like a tree. (This "undeveloped unity" is of course the only thing that spirit ever craved: every misogyny conceals a feminism, willy nilly, says Derrida.) Freud avers that the primal scene of life, more primal even than the primal scene that is seen by the Wolfman, is that of the breast viewed laterally. For every human infant, according to Freud's 1895 *Project towards a Scientific Psychology,* confronts the exigency of life, *"die Not des Lebens."* That exigency requires that the nipple of the breast, seen from the side, spark a reminiscence of the breast viewed from the front, a recollection of the full moon and the sun of aureole and nipple promising the flow of warm milk. For without such a reminiscence, the famished infant would not know how or where to turn its head, and would thereupon starve. Furthermore, were the infant merely to *hallucinate* the real presence of the full moon and sun it would in that case too expire. It would die happy, but it would die. The first genuine memory, therefore, must be the recollection of a perception of the breast full front; the second perception, the perception that triggers a memory of the first, must be the nipple viewed from the side after the infant's repletion. Hallucination or Real Presence? That is the question. And the answer, in both cases? The nipple, consubstantial with the Mother. One of the oldest images of Artemis is that of the cult statue in the Artemision of ancient Ephesus, the city of Heraclitus —Heraclitus, who says that our entire lifetime is but a child at play. We are all children, tossing the dice of hallucination and real presence on the steps of the temple. The goddess within exposes not merely two but three tiers of breasts, sufficient for countless mortal tuplets; the goddess is entirely gorgeous, with endless embonpoints and décolletés without limit. To be sure, the number of art historians and classicists who call the statue of Artemis at Ephesus "crude" or "monstrous" or "bestial" or at least "bizarre" is not small. Like spirit, these well-educated children are abashed. And yet the goddess wears a mural crown, and the entire city flocks to her. Her skirt is decorated with animals, yet she does not refuse the human animals. Art historians who are less abashed say that she represents *"die befruchtende und unermüdlich Alles ernährende Kraft der Natur,"* the fecund force of nature, nourishing all things without surcease. Mystical letters, never yet decoded, are incised on

Artemis of Ephesus (Roman copy), Ephesus Museum, Selcuk, Turkey. Photo ©D. F. Krell.

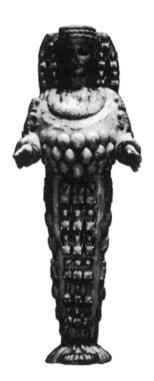

her crown, her girdle, and her feet. The hierodules who serve the Ephesian Artemis, the beautiful men and women of the city who serve as her priests and priestesses, offer themselves to pilgrims for whatever gifts the pilgrims can offer. That is how the splendid temple came to be built—from the offerings of those who received succor, some of whom, though certainly not all, were wealthy. And that is why the citizens cried out against the vulgar Roman Paul. They had taste. Perhaps one should hold out hopes for religion? And yet what infamy: two thousand years and not a single new goddess! Instead, Hegel mammering under his breast, sputtering on behalf of a spirit so scornful that it does not see what it craves. Some years ago, a novel by D. H. Thomas called *The White Hotel* was all the rage, although it now seems forgotten. It contains a restaurant scene, a scene in which a beautiful and generous woman exposes her breasts and allows her companions at the table to suck. She then suckles every person in the restaurant. They all line up in procession to her, all of them communicants who will bypass even bread and wine for warm milk. (It has been reported that the International Association of Restauranteurs tried to ban the novel when it first came out, complaining that its readers refused to be tempted by even the most lusciously worded menus, that they merely gazed languorously across the table at their companions and begged for suck.) Artemis of the teeming mammary: they seem to be loaves of bread, for this is the age when Artemis was also Demeter and Astarte and Kybele, not yet Diana the virgin huntress, not yet a member of the National Rifle Association. Or, if not exactly loaves of bread, sheaves of baguette carried under each arm, waiting only for Dionysus, who brings the wine. Bread and wine masticated to a pulp of warm milk, digestion turned to the outside. Perhaps one should hold out hopes for art as well? Breasts. If that is what they are, if I am not hallucinating. Either that or, taking the man at his word, taking the artist at least at some of his own words, here reproduced in no particular order, more or less asyndetically: spermsnakes coming apart in a motherforest of spiritual earthmother goddess dancingforest in adoration and gloria of the sexualization of spirituality (crossed out like Heidegger's *Sein,* if *seins* is what they are, for this would be the *seinsfrage*) vitalized by silent pandemonium (to the music of) Bruckner's and Mahler's 9ths Goretski's 3d Borodin's string quartet Händel's *concerti grossi* or Schubert's quintet of Trout in/out of the deep forms of things unknown in street or train or office (all connected by) the human bridge flowering trees rooted in rivers of water primordial slime on the beach at the sea of gloria gathering at the river a fountain in the sea of gloria she gloria starry starry night if everything is the same nothing is identical our lives in each other devouring gloria allegri miserere gloria gloria up.

Respondents

Pascale-Anne Brault is Professor of French at DePaul University. A specialist in contemporary French literature and thought, she is the translator with Michael Naas of Jacques Derrida's *The Other Heading* (Indiana), *Memoirs of the Blind* (Chicago), *Resistances of Psychoanalysis* (Stanford), *Adieu* (Stanford), *Rogues* (Stanford), and *Learning to Live Finally* (Melville). They also translated Jean-François Lyotard's *The Hyphen—Between Judaism and Christianity* (Humanity Books) and Jean-Luc Nancy's *Noli Me Tangere: On the Raising of the Body* (Fordham). She is a coeditor for Jacques Derrida's *The Work of Mourning* (Chicago) and *Chaque fois unique, la fin du monde* (Galilée).

Jonathan Lahey Dronsfield is Reader in Theory and Philosophy of Art at the University of Reading, UK. He also sits on the Academic Board of the Forum for European Philosophy, London School of Economics, and is a Permanent Fellow of the London Graduate School. He has published numerous papers and essays on artists, philosophy of art, aesthetics, and ethics, and has recently coauthored a book entitled *Materiality of Theory* (Article Press). Forthcoming is the monograph *Derrida and the Visual* (Edinburgh).

Ryan Feigenbaum is a PhD candidate at Villanova University. He is researching the development of the concept of life in the history of biology and its connection with contemporary politics.

Liam Heneghan is an ecosystem ecologist working at DePaul University as Professor of Environmental Science and Co-Director of DePaul University's Institute for Nature and Culture. His research has included studies on the impact of acid rain on soil food-webs in Europe, and on inter-biome comparisons of decomposition and nutrient dynamics in forested ecosystems in North American and in the tropics.

Paul B. Jaskot is a Professor in the Department of the History of Art and Architecture at DePaul University. His scholarly work has focused on modern German art and politics, with a specific interest in architectural policy and debates during and after the Nazi period. His most recent book is *The Nazi Perpetrator: Postwar German Art and Rightwing Politics* (Minnesota).

Ashby Kinch is Associate Professor of English at the University of Montana, where he teaches medieval literature. His current book project is *Imago Mortis: Mediating Images of Death in Late Medieval Culture.* He coedited an anthology of essays, *Chartier in Europe* (Boydell and Brewer), on the reputation and influence of the fifteenth-century French poet Alain Chartier, and he has published articles on Old and Middle English lyric, late Middle English literature, and medieval macabre art.

Sean D. Kirkland is Associate Professor of Philosophy at DePaul University. He has recently published a monograph entitled *The Ontology of Socratic Questioning in Plato's Early Dialogues* (SUNY), and he has written essays on subjects ranging from Plato, Aristotle, and Greek tragedy, to Nietzsche's philosophy of history and Heidegger's phenomenology.

David Farrell Krell is Emeritus Professor of Philosophy at DePaul University and has taught at the Universities of Freiburg, Mannheim, and Essex. He lives and writes near Freiburg, Germany. In addition to works of philosophy, he has published three novels and a number of short stories.

Karmen MacKendrick is Professor of Philosophy at Le Moyne College. She is the author of several books —most recently *Divine Enticement: Theological Seductions* (Fordham) — and is interested in all manner of connections among bodies, times, desires, and words.

William McNeill is Professor in the Department of Philosophy at DePaul University. He is author of *The Glance of the Eye: Heidegger, Aristotle, and the Ends of Theory* (SUNY) and *The Time of Life: Heidegger and Ēthos* (SUNY), and has translated a number of works by Heidegger. His research interests include Nietzsche, Hölderlin, and ancient philosophy, as well as Heidegger's thinking on art and *technē*.

Andrew J. Mitchell is Assistant Professor of Philosophy at Emory University. He is the author of *Heidegger among the Sculptors: Body, Space, and the Art of Dwelling* (Stanford), translator of Heidegger's *Bremen and Freiburg Lectures: Insight into That Which Is and Basic Principles of Thinking* (Indiana), and coeditor of *Derrida and Joyce: Texts and Contexts* (SUNY). His work explores issues of mediacy, meaning, and relationality.

Malek Moazzam-Doulat teaches in the Religious Studies Department at Occidental College in Los Angeles. His research is focused on political theory and religion and, in particular, on the relationship between Islamic and European philosophical responses to modernity and imperialism. His most recent work addresses the philosophical and religious grounding of torture and suicide bombing.

Michael Naas is Professor in the Department of Philosophy at DePaul University. He works in the areas of ancient Greek philosophy and contemporary French philosophy. His most recent book is *Miracle and Machine: Jacques Derrida and the Two Sources of Religion, Science, and the Media* (Fordham). He is also the cotranslator with Pascale-Anne Brault of several

works by Jacques Derrida, including two books on art, *Memoirs of the Blind* (Chicago) and *Athens, Still Remains* (Fordham).

Elizabeth Rottenberg is an Associate Professor of Philosophy at DePaul University and a candidate at the Chicago Institute for Psychoanalysis. She writes on late modern and contemporary European philosophy as well as on psychoanalytic theory. She has translated books by Lyotard, Derrida, and Blanchot, and is the author of *Inheriting the Future: Legacies of Kant, Freud, and Flaubert* (Stanford).

H. Peter Steeves is Professor of Philosophy at DePaul University, where he specializes in ethics, social/political philosophy, and phenomenology. Steeves' books include *Founding Community: A Phenomenological-Ethical Inquiry* (Kluwer); *Animal Others: On Ethics, Ontology, and Animal Life* (SUNY); *The Things Themselves: Phenomenology and the Return to the Everyday* (SUNY); and *Being and Showtime* (forthcoming).

Peter Trawny takes a phenomenological-hermeneutical approach to the fields of poiltical philosophy and aesthetics. He has written several books on such topics as Heidegger, Hegel and Schelling, Arendt, and Plato, and has worked as the coeditor of the Heidegger's *Gesamtausgabe* (Vols. 35, 69, 73, 90). His latest publications are *Adyton. Heideggers esoterische Philosophie* (Matthes & Seitz) and *Medium und Revolution* (Mathes & Seitz). He is currently working on a phenomenology of intimacy.

Dolores Wilber has operated her own graphic design and multidisciplinary arts practice for over twenty years. Her approach embraces cross-pollination between art and design in print, installation, video, performance, and radio. Her work has been exhibited widely in the U.S., as well as in England, Estonia, Portugal, Germany, and China. She is a Professor of Graphic Design in the College of Computing and Digital Media at DePaul University.

Peter Karklins left Latvia in his mother's womb and was born in
Frankfurt an der Oder in Germany on January 27th, 1945. His maternal
grandfather fought on behalf of the Latvian national democratic movement and
became a lieutenant colonel in the Independent Latvian Army. His paternal grandfather was
a *basso* in the Latvian National Opera in Riga. His mother, Zenta, studied Baltic philology. His
father, Erik, was an architect, and was wounded on the Eastern Front in World War II after
being conscripted into the Latvian Legion, a division of the Waffen-SS. After emigrating
from Germany in 1951, his family lived in the Belmont Cragin
neighborhood in northwest Chicago, where Karklins attended
Schubert Grammar School and Foreman High School.
While working on an assembly line
for the Zenith Radio Corporation, he enrolled
part-time at Wilbur Wright College. There he studied painting
with Frederick Armour, and at Howard Albert's Pauper's Press, he received
instruction in copperplate engraving. He later studied sculpture with Cosmo Campoli
and Paul Zakoian at the Contemporary Art Workshop. Along with Albert, Campoli, and
Zakoian, many figures from the Chicago art world have numbered among Karklins friends,
such as Jack and Lynn Kearney, the sculptor Sara Szold, and the painter Kit Schwartz. He
started work as an apprentice architectural model maker in 1968 at C. F. Murphy
(now Murphy/Jahn). He became chief model maker for that firm in 1973 and
held the same position at Perkins & Will from 1976 to 1985, after
which he was proprietor of Architectural Presentation Services until 1992.
Abandoning architectural model making, Karklins began working as a night
watchman to support his art and was employed from 1996 to 2009 at various locations
around Chicago. This is the period during which the drawings presented here were
composed. As their sometimes detailed verso accounts indicate, these works were produced
at his post, working through the night, or on the train to and from work.
Since 2002 Karklins has been a resident artist at the Flatiron Arts Building
in the Wicker Park/Bucktown neighborhood of Chicago. He has exhibited with
the Thomas McCormick Gallery and he is now represented by Aron Packer at Packer Schopf
Gallery. Karklins and his ex-wife, Barbara, have three daughters, Lija, Daina, and Andrea.